A Picture Book of Cats

Copyright ©A Bee's Life Press All Rights Reserved

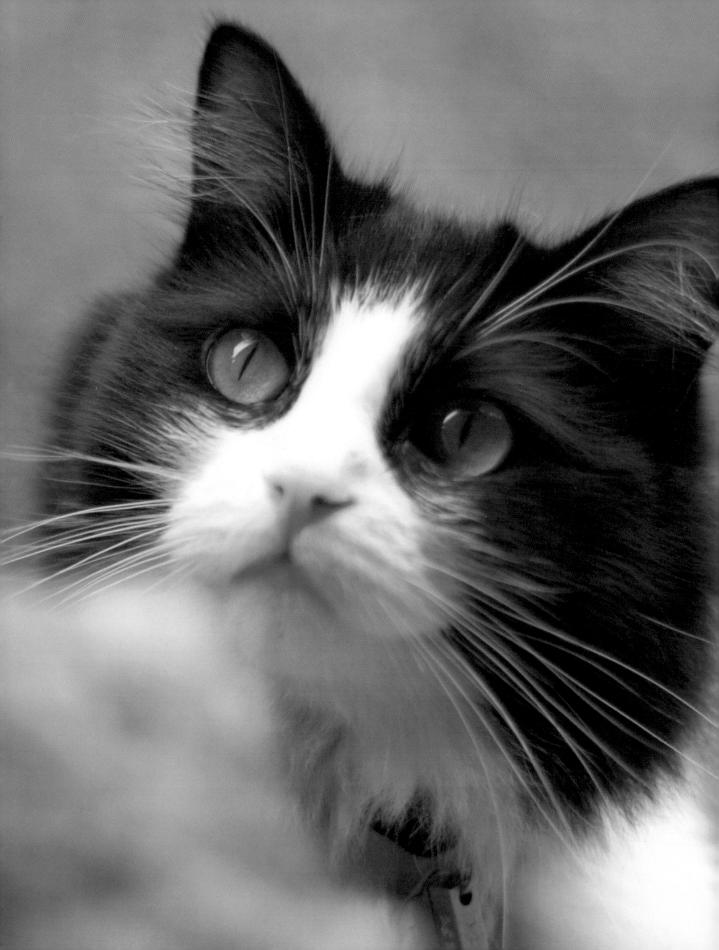

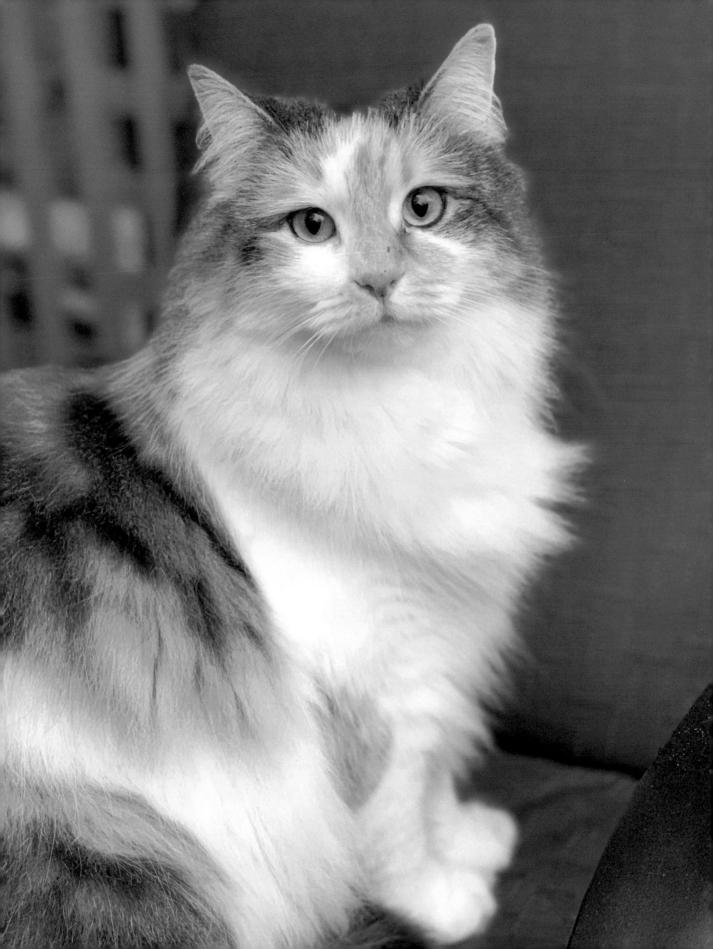

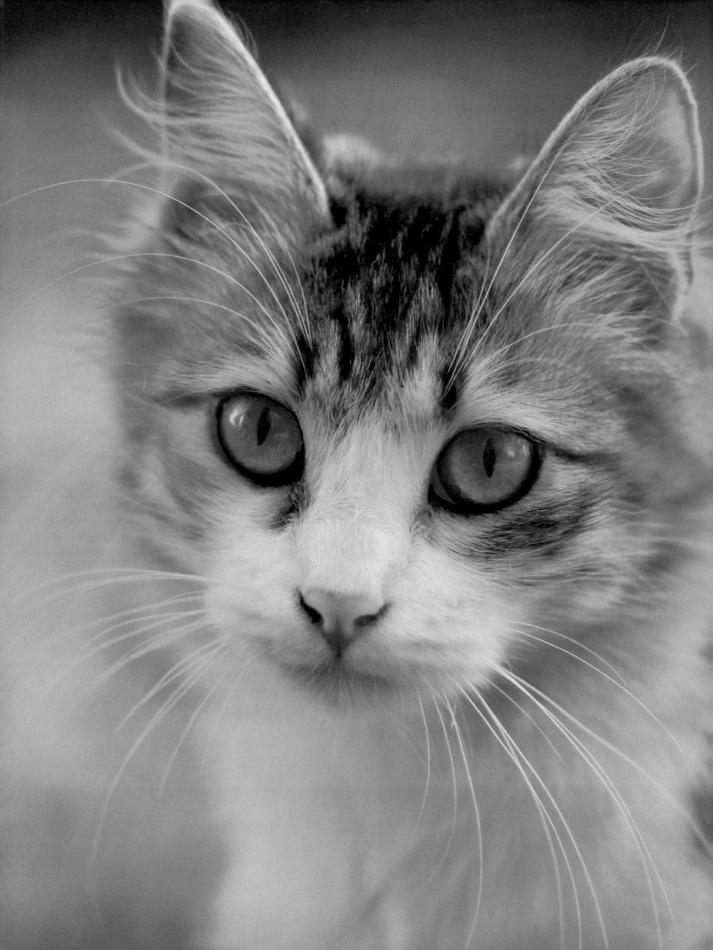

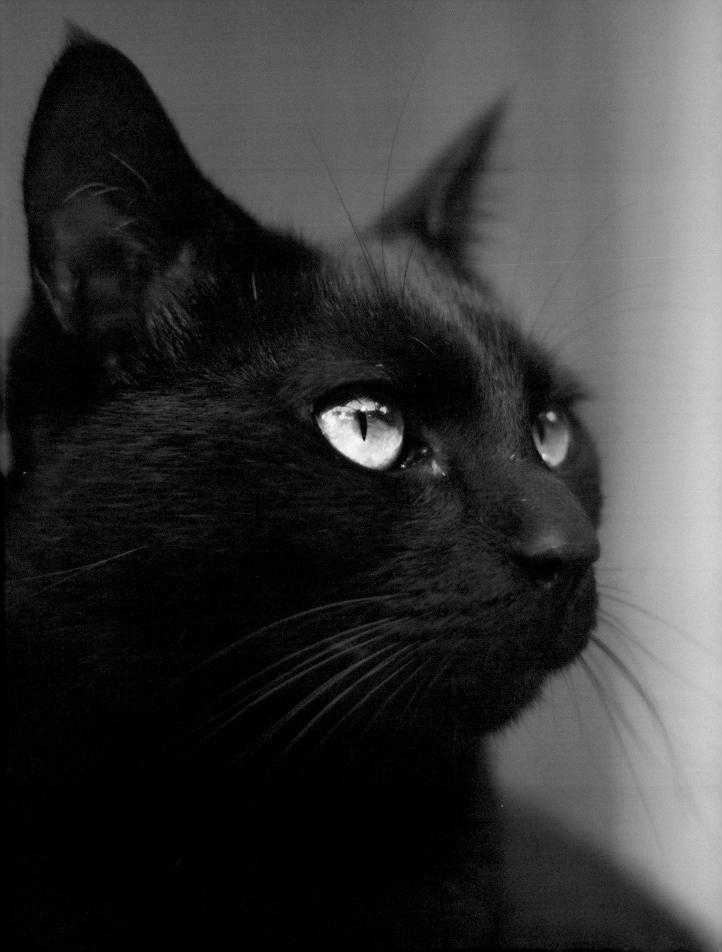

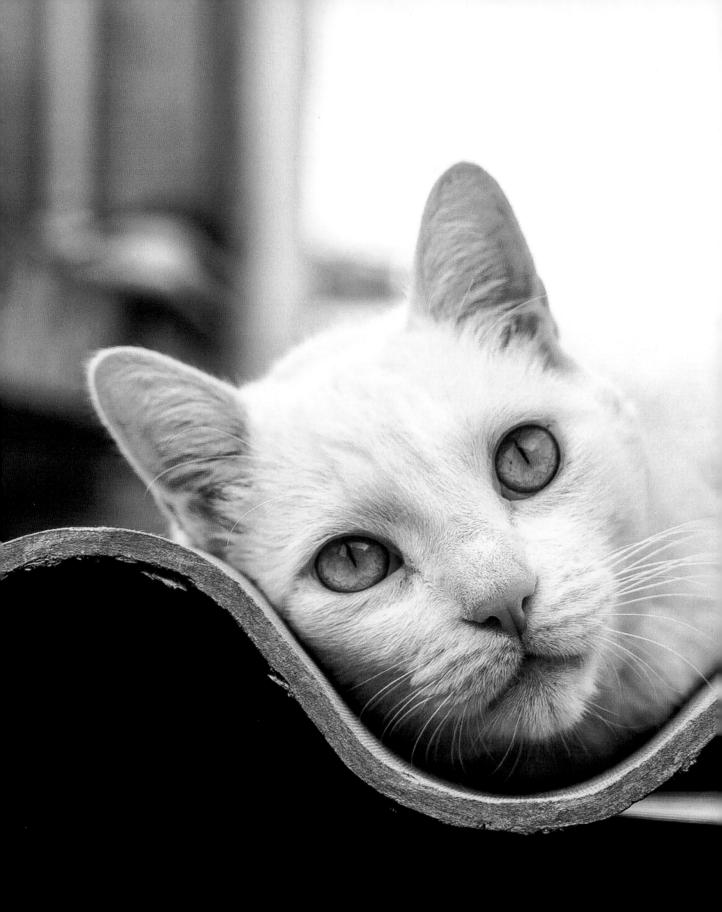

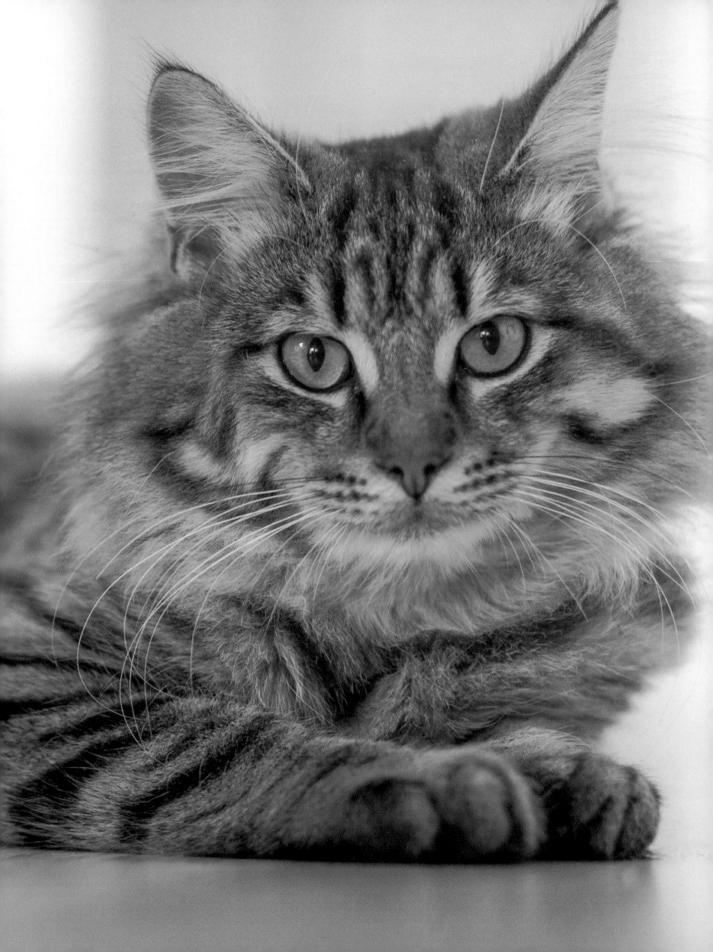

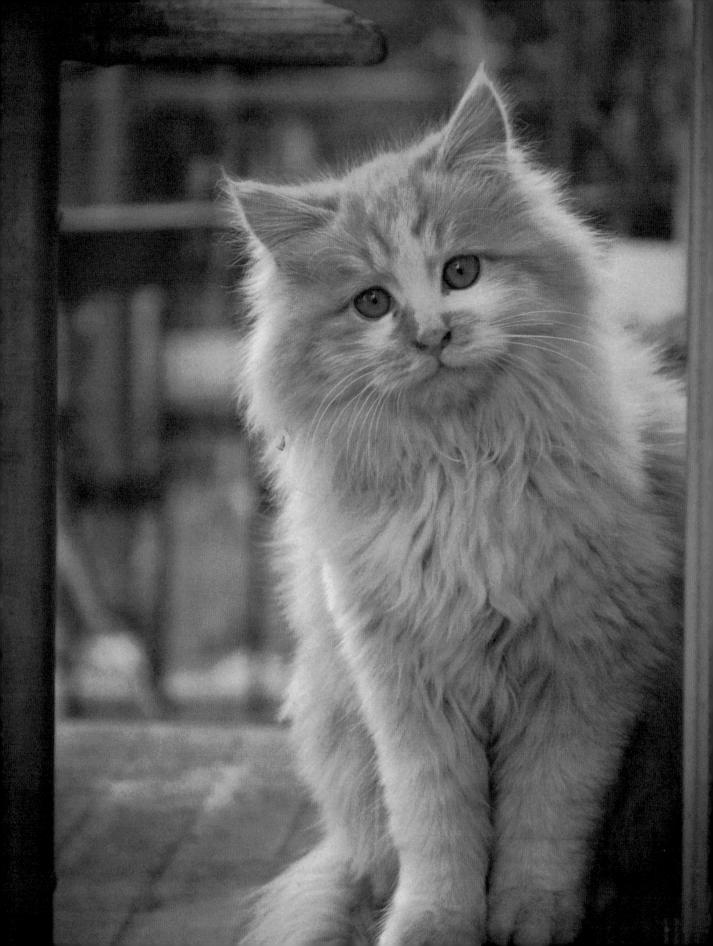

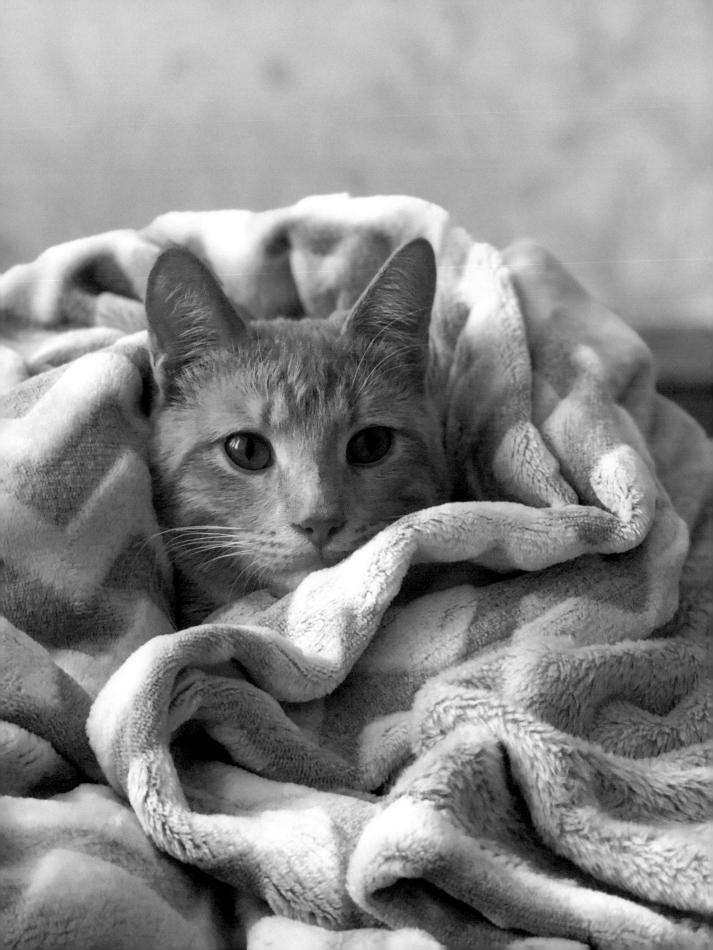

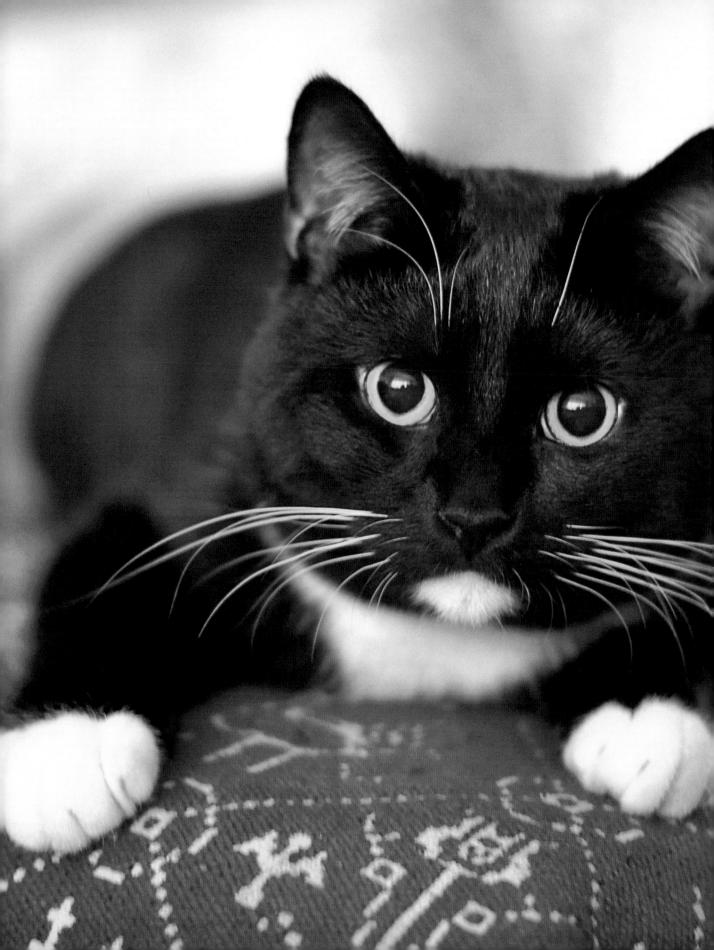

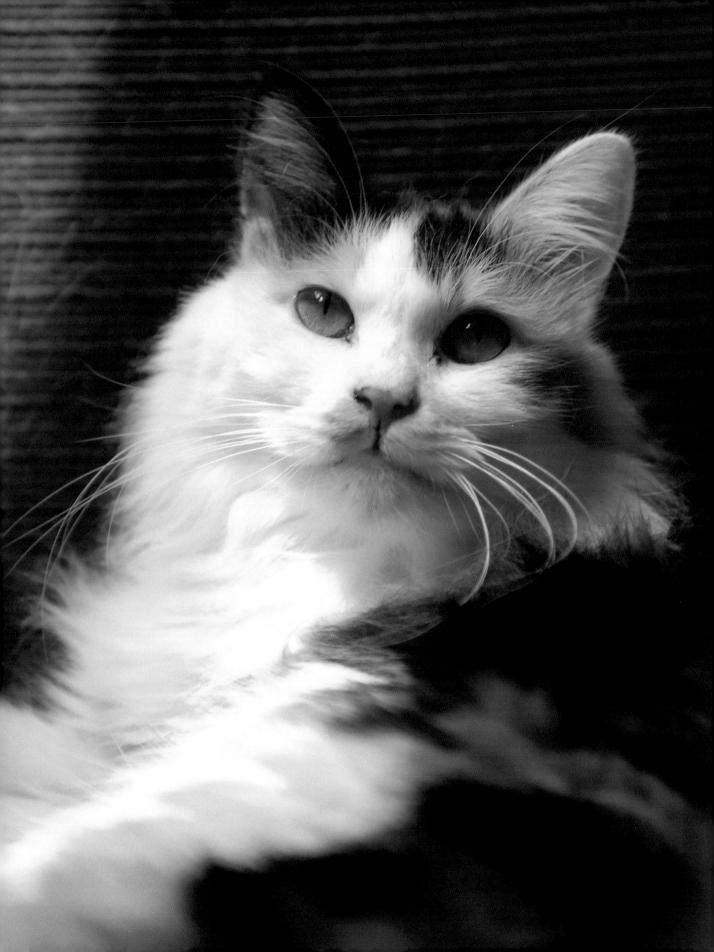

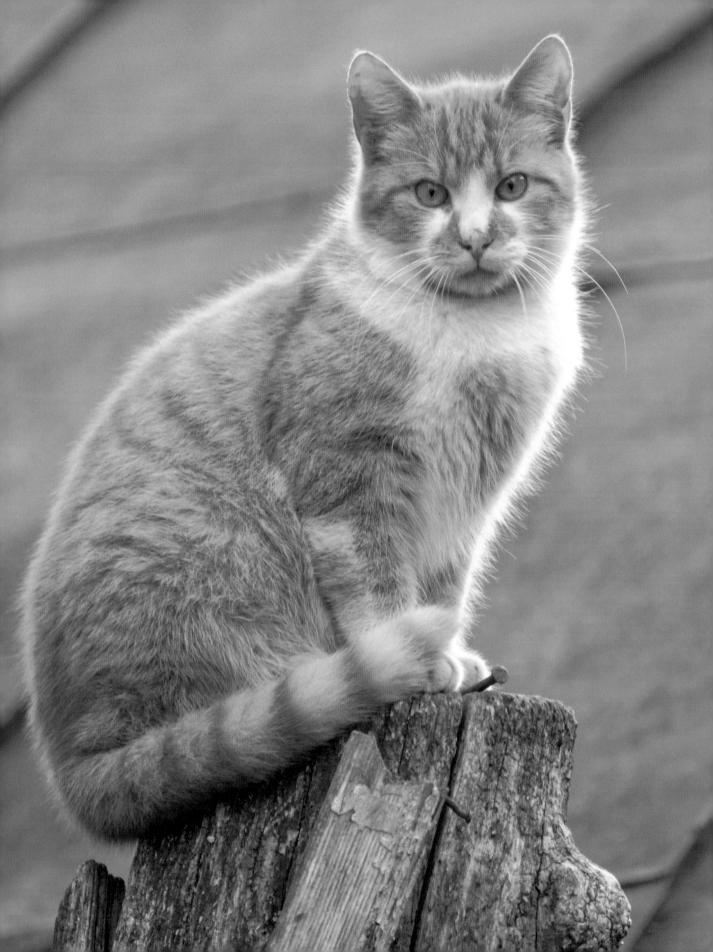

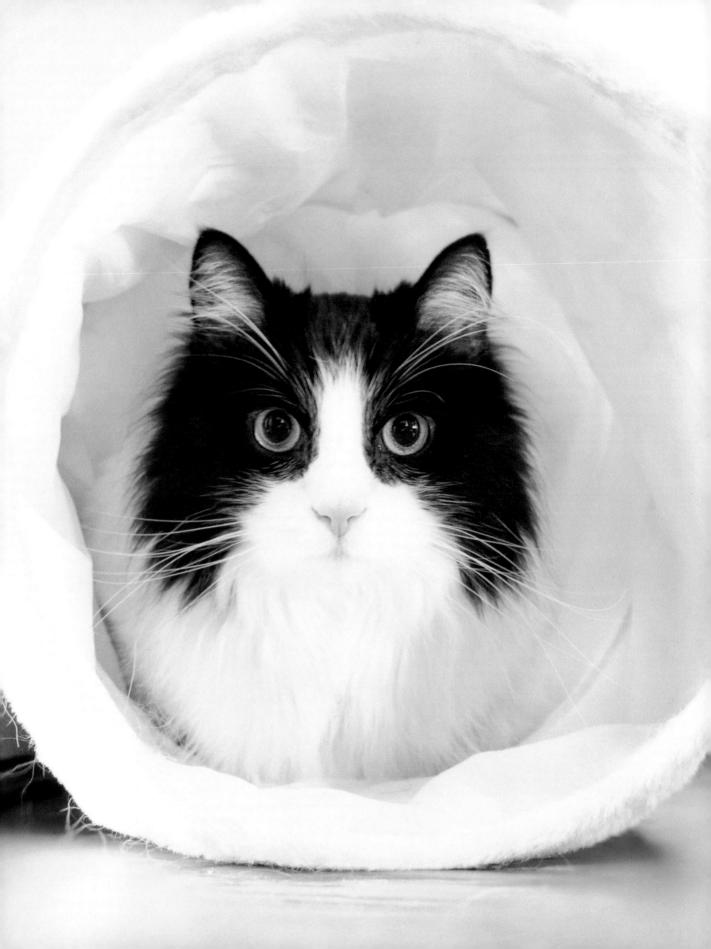

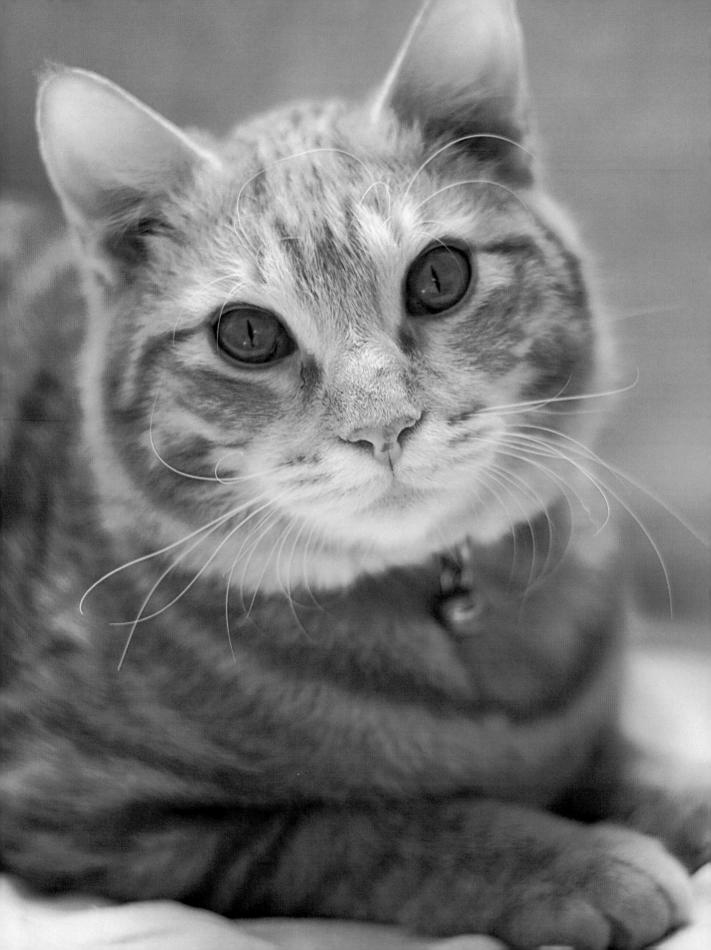

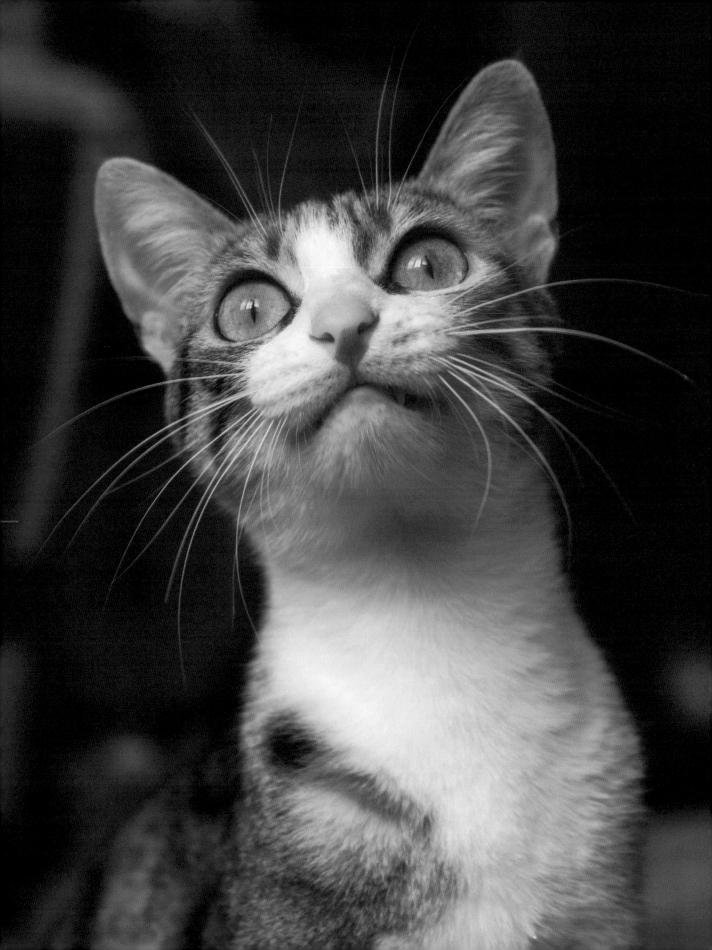

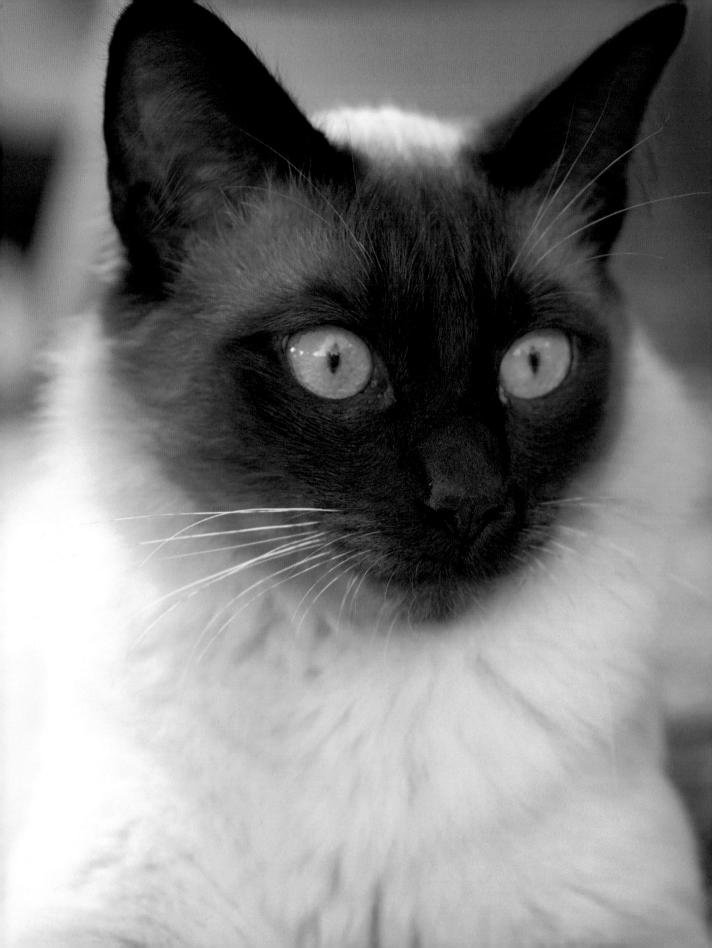

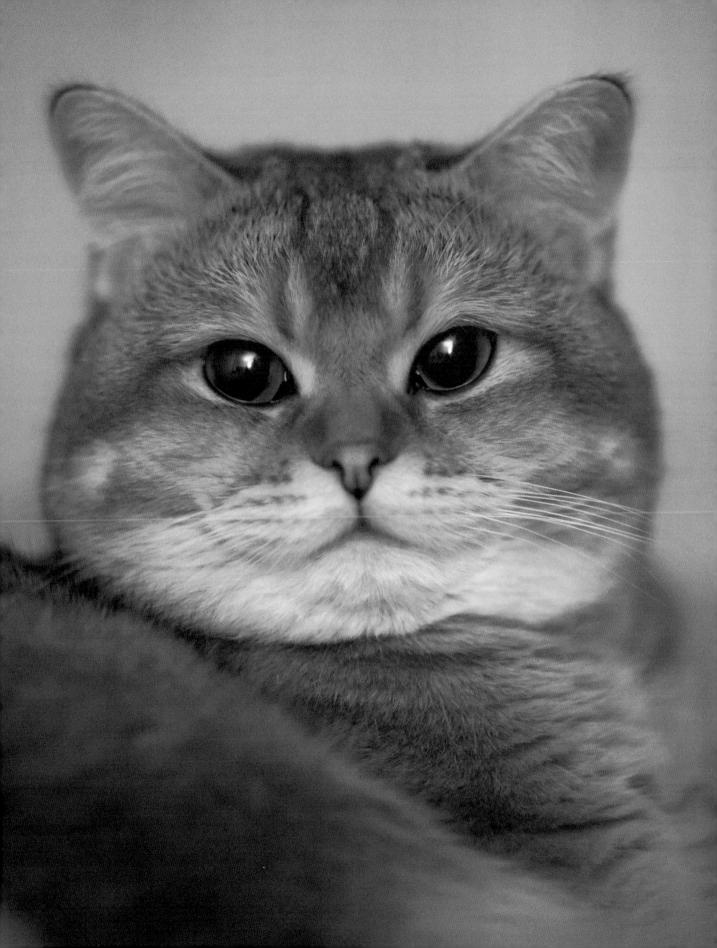

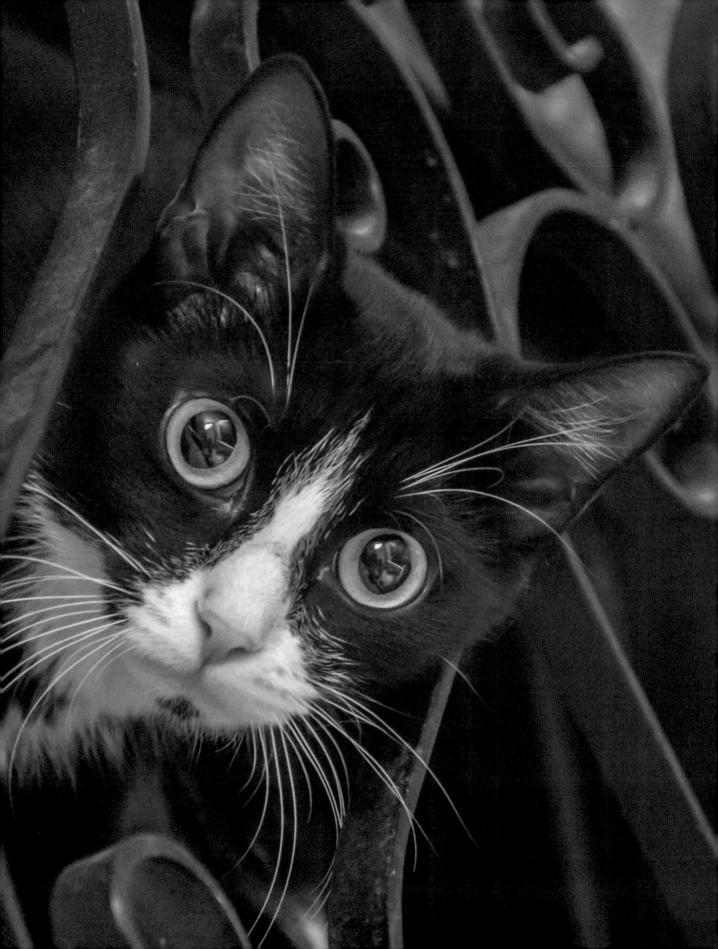

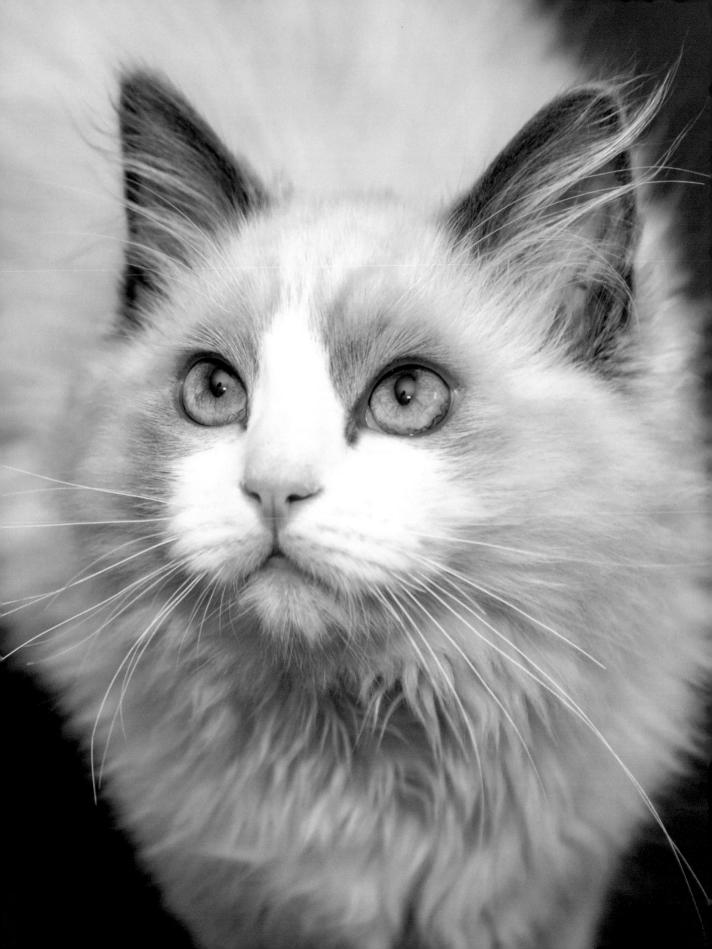

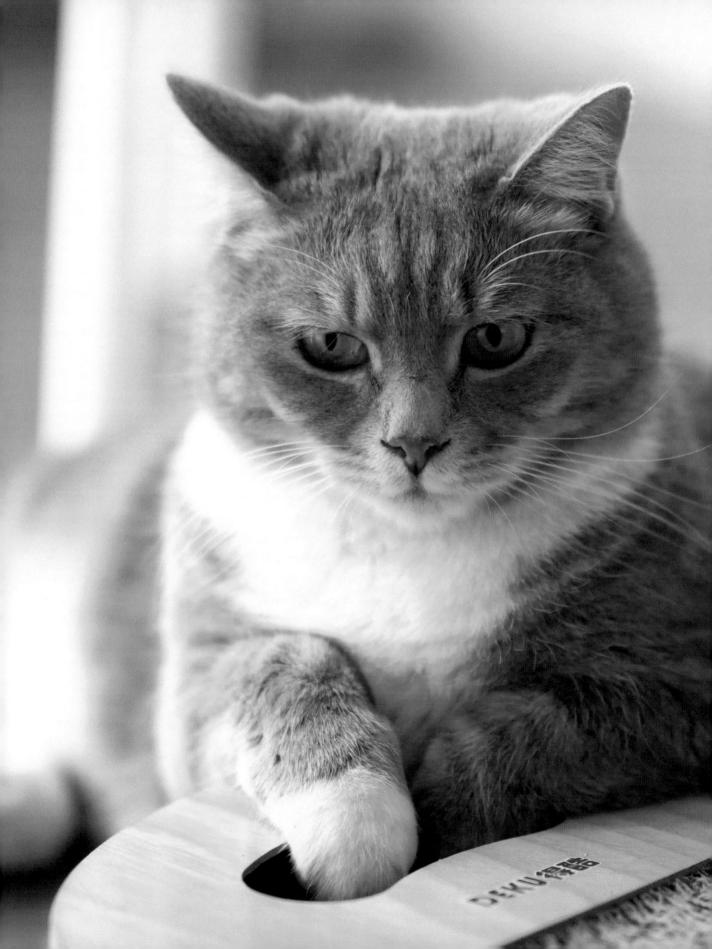

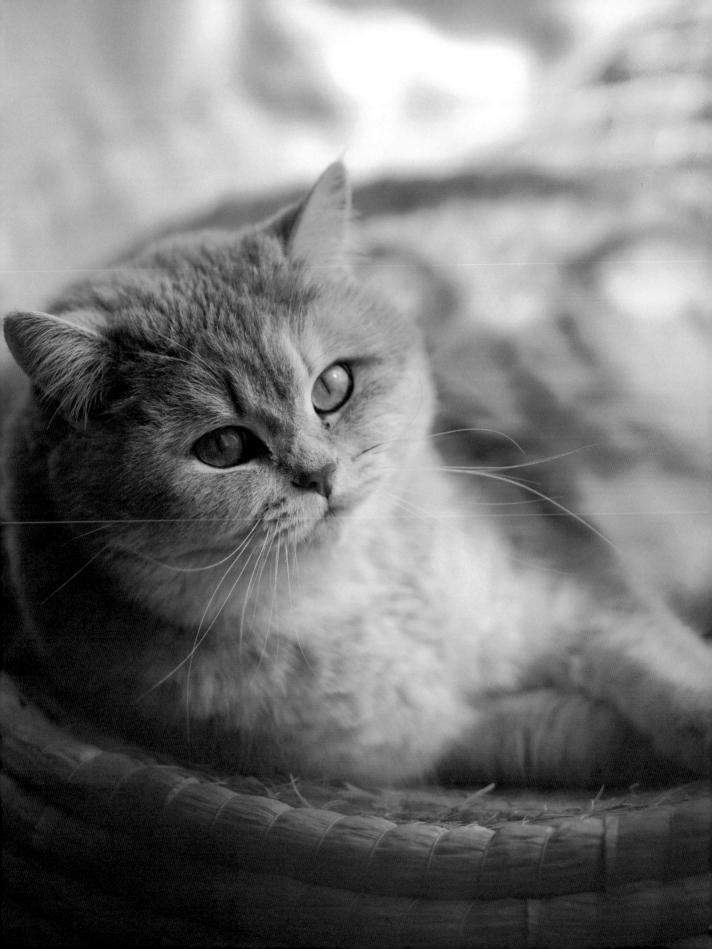

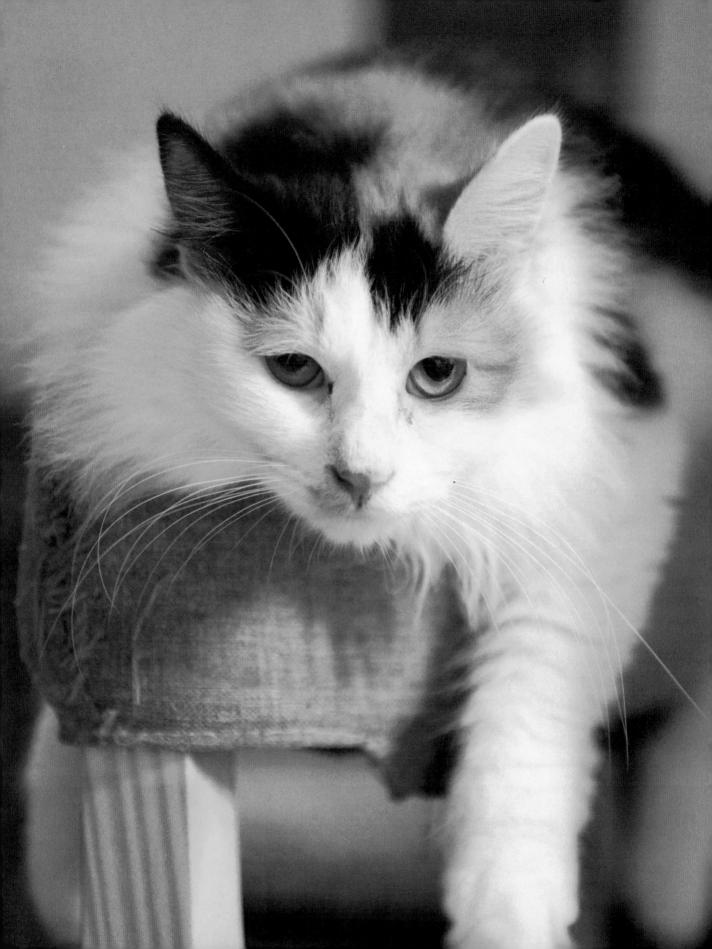

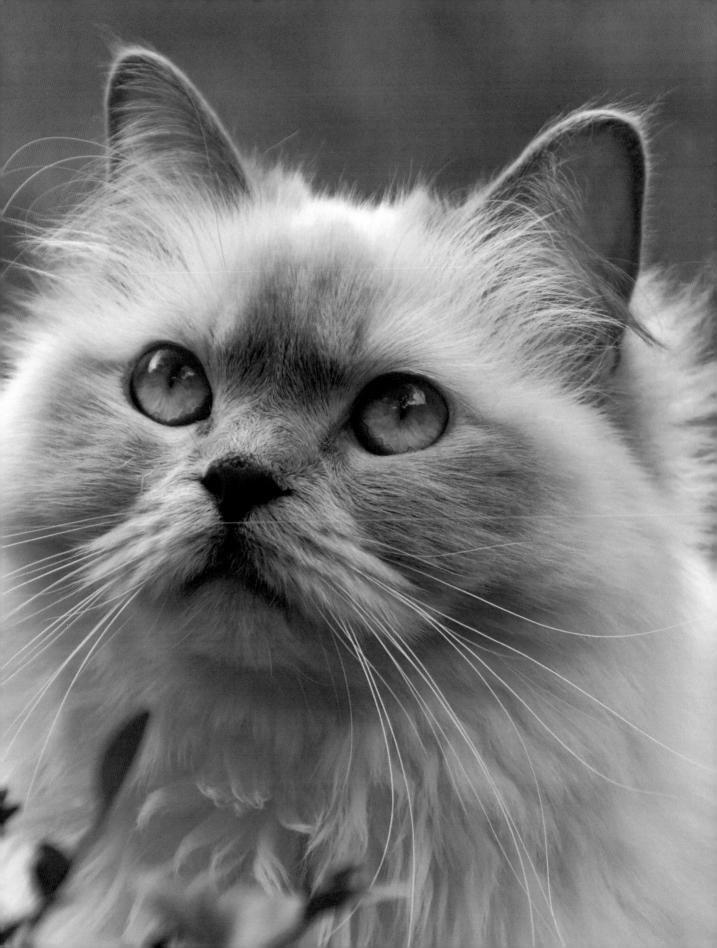

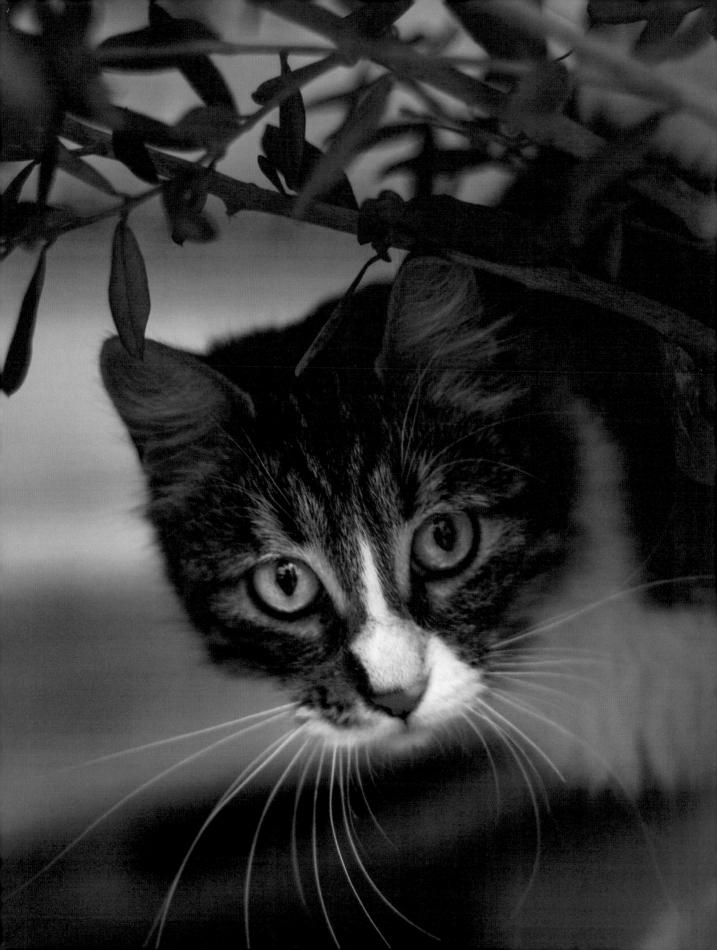

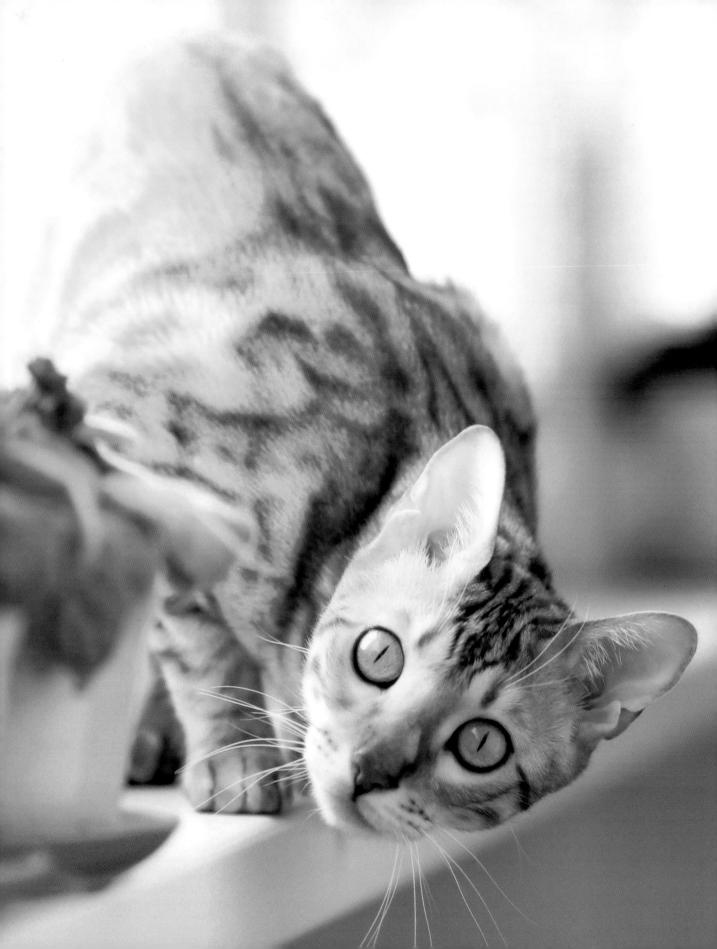

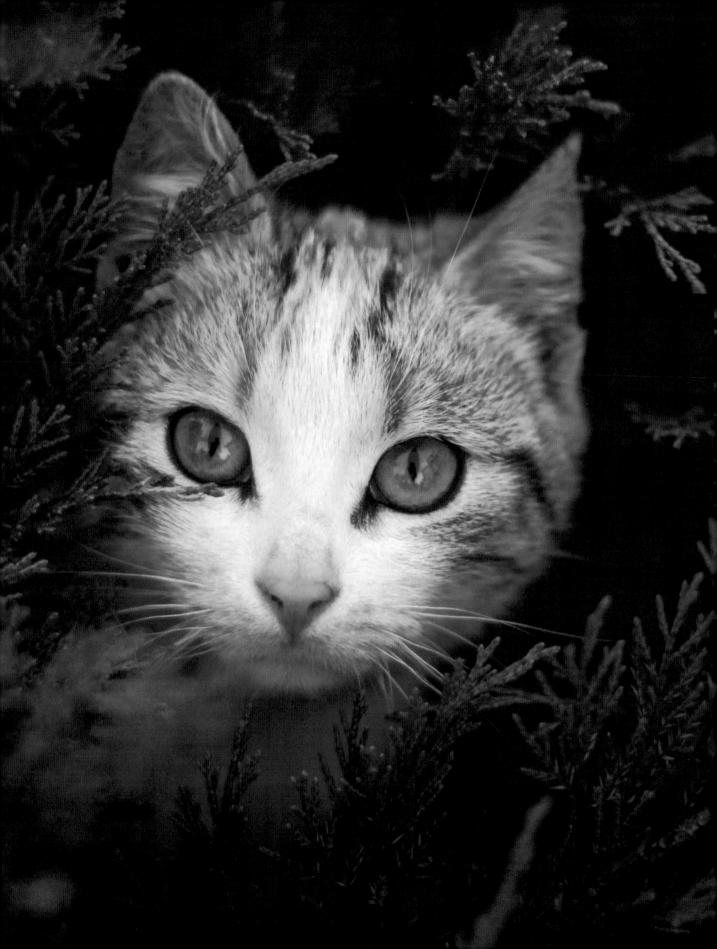

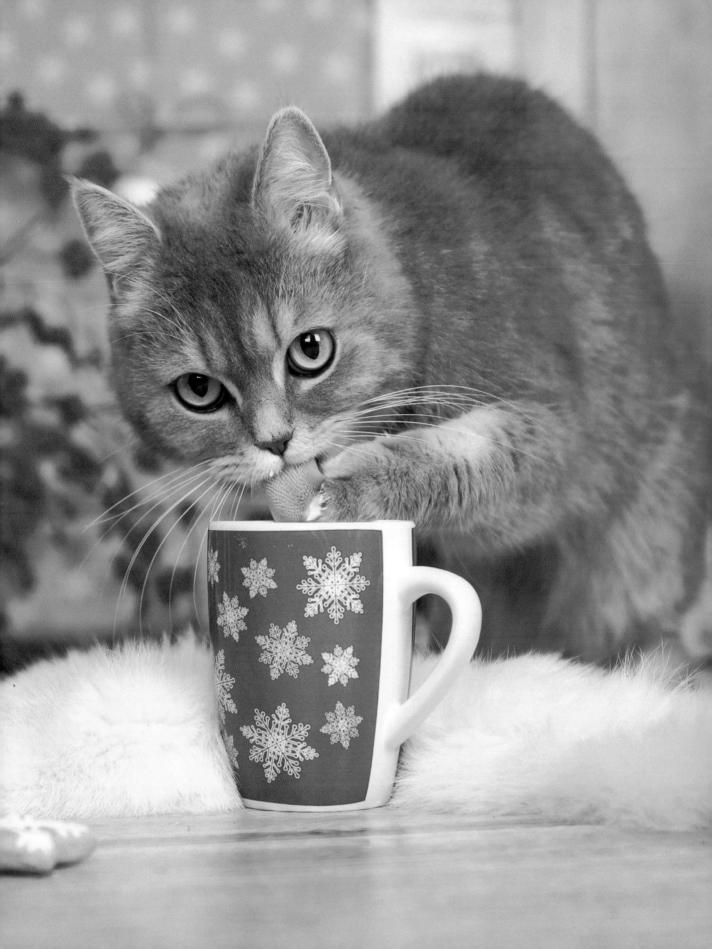

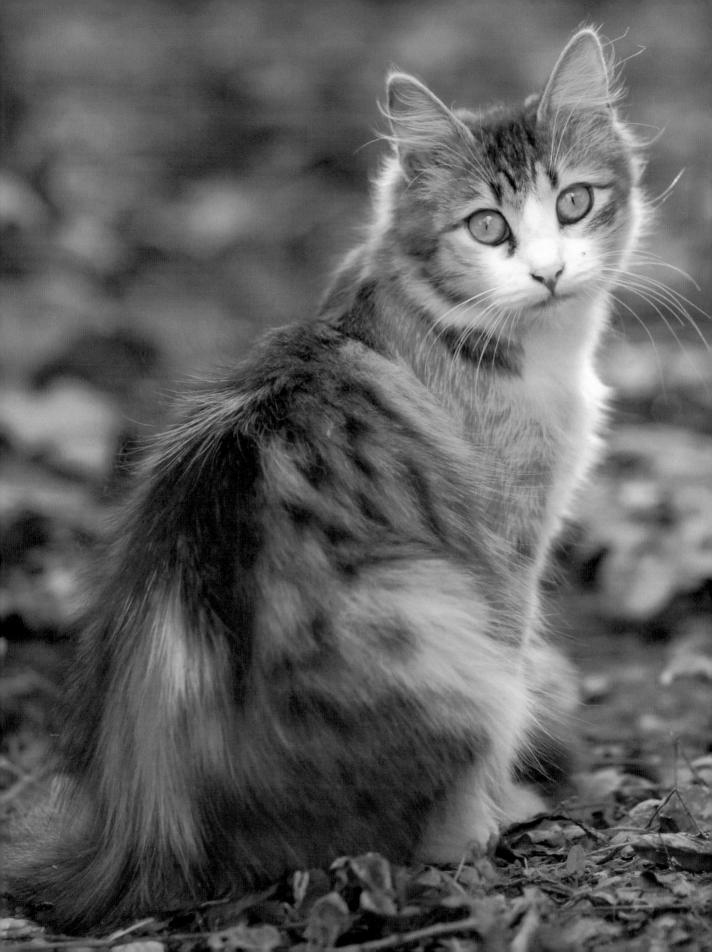

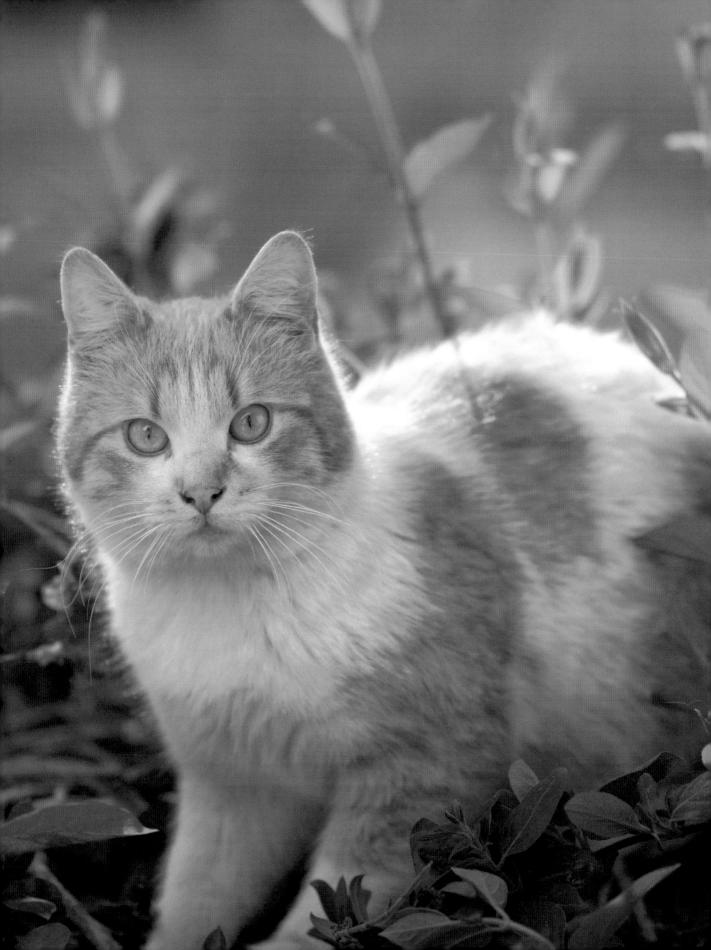

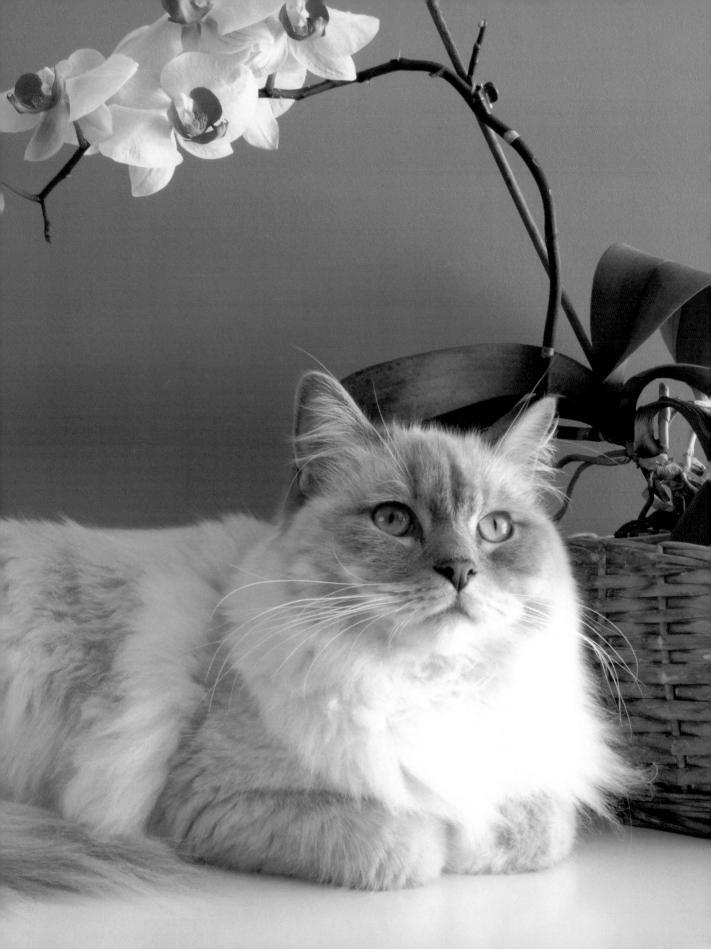

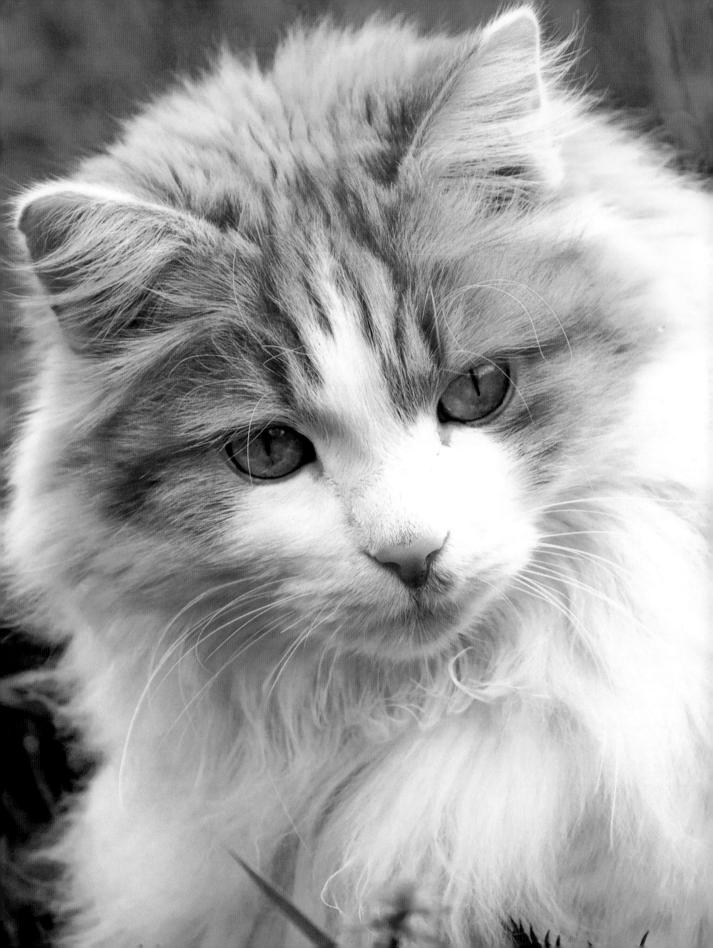

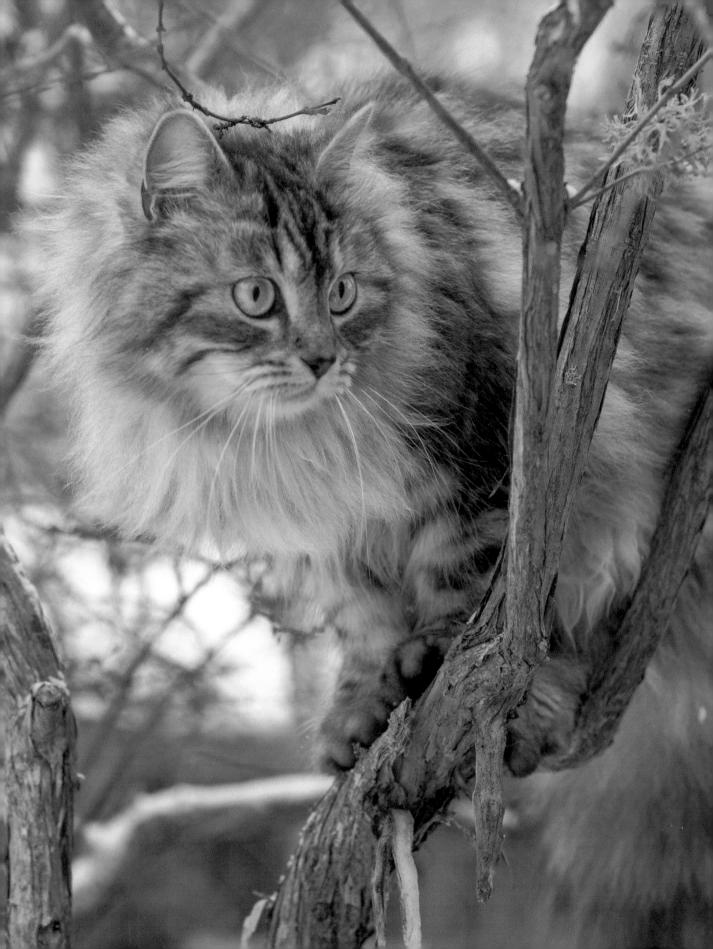

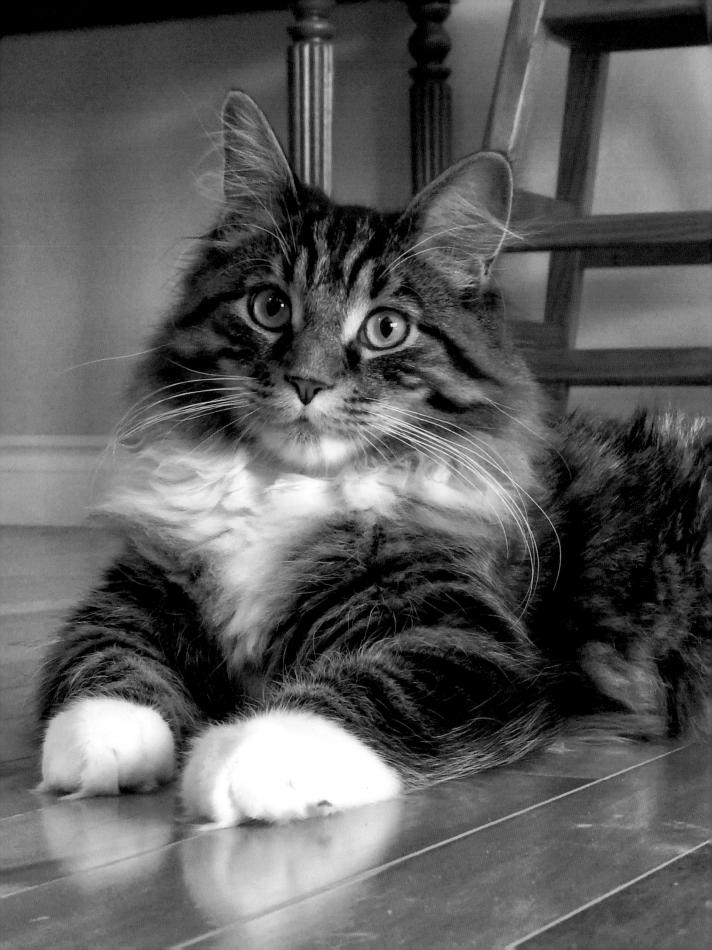

Printed in Great Britain by Amazon

30255493R00025